# YOU ARE POSITIVELY AWESOME

To Jon, thank you for being the very, very best husband and cheerleader.

To my life's brightest sunshines, Matilda, Arthur and Maisie.

And to my awesome, inspiring Mum.

Love you zillions.

# STACIE SWIFT

# YOU ARE POSITIVELY AWESOME

GOOD VIBES and SELF-CARE PROMPTS
for ALL of LIFE'S UPS and DOWNS

PAVILION

# CONTENTS

# HEY!
# YOU'RE
# AWESOME

Hey, reader of this book!

YOU ARE POSITIVELY AWESOME.

It's so easy to forget that.

Life gets in the way, we keep adding to our to-do lists and firefighting our way through (big and small) daily battles.

But you are capable, you are interesting, you can do hard things.
You are enough, just as you are.

We fail to remember our awesomeness and we don't give ourselves the credit we deserve. But this book aims to change that. I want to remind you of all the reasons you are your own kind of wonderful; to provide ideas and tools to help you through the days that feel grey; and to shine a light on the ways you can be your truest, sparkliest self.

ME

I don't claim to be an expert.

But I am a fully-fledged empath, excellent cheerleader (in the supportive sense, I couldn't do a handstand if you paid me), self-care enthusiast and proud member of the 'I'm not sure how, but we will get through this' club.

Qualifications like this obviously don't come for free; I've earned my stripes!

In fact, like lots of us, I've had my fair share of stormy times.

I supported my boyfriend (now husband) through cancer. I've championed those closest to me through mental health struggles. Family estrangement, loss and grief have all been thrown in for good measure. I've had three babies in four years and particularly gruelling pregnancies.

That's all on top of the drip, drip, drip of everyday rain showers. The juggle, never-ending mum-guilt, trying to maintain friendships, everyday anxieties (don't get me started on the stress of parallel parking) and wondering when I will get time to try all of the projects and recipes lingering on my Pinterest boards...

Top that with some imposter syndrome, poor body image, too much social media-ing, not enough rest and the constant nagging feeling of not quite being or doing enough.

I've got first-class honours in this stuff!

Through these good days and bad days, I draw and I write: bold rainbows of illustrations and peeks into the ups and downs of my life that I share online.

With every illustration I share and each social media post,
I'm reminded it's not just me.

It's not just me that struggles with self-care; not just me who sneaks off for a cry when the washing is piling up and the kids are bickering; not just me who is juggling work and life and feeling bulldozed by the big stuff and overwhelmed by the little stuff.

And if it's not just me, it's not just you either.

Remember, we are all in this together.

We all need a bit of TLC and a gentle reminder every so often.

We have all survived every bad day and overcome every obstacle we've faced.

And for the times we don't feel like the very best version of ourselves, this book promises to bring colour to the greyest of skies.

Whenever we need a little more empathy and self-compassion this book will inspire an extra dose of self-love.

For all of us spinning too many plates, comparing our worst days to a constant stream of shiny, staged, social media photos, compromising boundaries and putting self-care at the bottom of the to-do list, these pages are packed with positivity, illustrated reminders and tips you can use every day.

They are sprinkled with activities to encourage us to identify and highlight ways to keep us twinkling: I promise you a rainbow of inspiration and kindness that will help even on the darkest of days!

You've got this.

Chapter 2

WHY IS THIS STUFF IMPORTANT?

We're constantly busy, constantly juggling.

We are forever doing more and stopping less. The incessant go, go, go of life ultimately means looking after ourselves falls to the bottom of our list of priorities and we forget our own capabilities and awesomeness.

We people-please and take on too much.
We compromise our boundaries.
We keep going until we feel run down and empty.

Our sparkle dims.

We get used to being last on the 'things to take care of' list, and it can be hard to shift the spotlight onto our own well-being.

Self-care, self-acceptance, self-love, self-kindness, self-worth... all the focus on 'self' feels selfish and indulgent - so even if we do find the time, why do we deserve so much of our own care and attention?

We just aren't able to give endlessly without topping ourselves up first. It's a simple enough idea, but it's also the foundation on which we can best pursue and maintain our twinkliness and happiness.

## WE HAVE TO TAKE BETTER

## CARE OF US.

# SPARKLE

Investing in our mental and physical wellness ensures we can be the best, sparkliest version of ourselves at all times, whatever the weather, whatever life throws our way.

How we choose to replenish our cups is as unique and individual as everything else about us. There's no 'one size fits all' answer, but there are some things we can all do, practised in our own way, to treat ourselves a little better:

Acknowledge we are deserving of our own love and kindness

Treat ourselves with the compassion we would show to others

Accept everything about ourselves: the good, the bad (and the non-Instagrammable)

Create strong and clear boundaries

Build our self-belief and work on our self-worth

Find joy in our everyday experiences

Remember we are strong, resilient and a unique force of nature

Knowing this is one thing, but in reality, of course, putting it into effect can be tricky.
We need to make a commitment to ourselves...

# I AM POSITIVELY AWESOME

## M A N I F E S T O

your name ↵

I _____ believe in myself, take care of myself and prioritize my needs so I can be the very best, SPARKLIEST version of me that is possible.

I am strong, capable and resilient and have weathered every storm that has come my way.

doodle a
self-portrait

I know my worth and recognize my value.

My feelings are valid and don't require
explanation or justification.

I am a perfectly imperfect
work in progress.

I matter.
I belong.
I am enough - even on my wobbly days.

* I AM POSITIVELY (undoubtedly) AWESOME. *

GIVING OURSELVES THE LOVE AND
ATTENTION WE DESERVE MEANS WE ARE
MORE CAPABLE OF GIVING TO OTHERS.

SELF-
CARE
isn't
SELFISH

We might worry that focusing on our own needs will result in people liking us less.

The truth is, we can't control the feelings and reactions of anyone else, positive or negative. We are only able to change our own thoughts and actions.

We might feel constrained by finances, time or ability.

We can only do what we can. And that's okay.

Even our smallest acts of self-kindness can make a difference: being more mindful with our use of social media, practising positive self-talk, prioritizing early nights over Netflix... it all adds up.

We might be overwhelmed with plans to aim big;
to approach self-care with a dramatic overhaul
and great gusto
(all my fellow overachievers, I'm talking to you!).

Step back. Slow down.
Sneaking small wins into our everyday lives can be
the spark that transforms into steady radiance!

We just might not feel worthy.

Despite what our inner voices may tell us.
We matter.
Our happiness matters.

# THINGS THAT HELP ME SPARKLE

Make a note of the things that make you feel your very best.

people

indoor activities

places

social media
accounts

books

hobbies

outdoor
activities

WE DESERVE TO GIVE TIME TO THE THINGS THAT
HELP US KEEP SPARKLING AND SHINING OUR BRIGHTEST.

Being dedicated to looking after ourselves equips us with the resources we need to deal with the huge and the small things; it makes our outlook more positive as well as keeping us happier and healthier.

We are better able to pick ourselves up and dust ourselves down when we face hard times, or wobble, or realize we've just stopped feeling as awesome as we could do.

WE ALL HAVE TIMES WHEN LIFE IS A BIT RAINY

On difficult days, the storm clouds arrive and things feel messy and hard to manage - it seems as though the bad outweighs the good, and so our ability to recognize our strength diminishes.

We fixate on our perceived shortcomings: everything we don't have; the emotions too big to share in 280 characters; the ways we aren't living up to our own expectations; the things that can't be easily tidied away out of view and kept hidden from judgement and comment.

When we are wading through our messiest times and only see our flaws, it is easy to assume that everyone else has it together. Other people's lives look neat and simple, perfectly ordered and contained - we focus on the highlight reels we are shown on social media and don't step back to see the full picture.

We might feel overwhelmed, embarrassed and solitary in our struggles, but it's important to remember we are not alone.

While everyone else's forecasts may give the impression of being 100% sunshine, the rain showers happen to us all, without exception.

notes for tough days:

NO FEELING IS FINAL

IT'S OK TO TAKE IT ONE DAY AT A TIME

YOU ARE so very STRONG

ASKING FOR HELP IS NOT WEAKNESS

YOU ARE LOVED

Our triggers and tolerances
will be varied.

Our perceptions will be unique.
Our experiences are entirely individual.

Our feelings, our messy times, our not-
feeling-too-awesome days are all valid.

THERE IS SUNSHINE
INSIDE YOU, EVEN
WHEN YOUR SKIES
ARE STORMY.

There is strength in our vulnerability.

Our turbulent days aren't a sign
of weakness.

# STRENGTH

Sprinkling some honesty through our lives, on and offline, gives us the opportunity to be the light in someone else's dark days.

By allowing ourselves to be open and authentic, we can shine a little brighter too.

Strength through the stormiest times doesn't mean shouldering the clouds alone.

# STRENGTH CAN LOOK LIKE:

REACHING OUT FOR HELP

GIVING OURSELVES OPPORTUNITY FOR GROWTH

PUTTING OURSELVES FIRST

DOING WHAT WE CAN WITH WHAT WE HAVE

SLOWING DOWN

EMBRACING OUR FEELINGS

We might not be able to stop every rain shower, but there are some things we can do to help when we feel overwhelmed.

..............
..............
..............

THE PAST

..............
..............

THINGS WE
CAN'T
CONTROL

OTHER PEOPLE'S
ACTIONS

OTHER PEOPLE'S
THOUGHTS

..............
..............
..............

FILL IN THE GAPS WITH SOME OF YOUR OWN

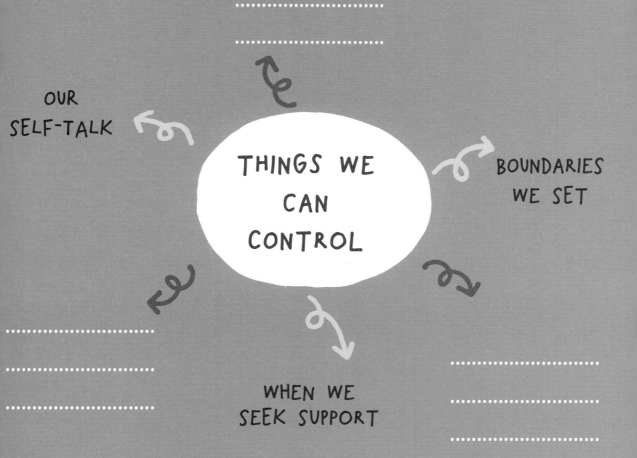

OUR
SELF-TALK

THINGS WE
CAN
CONTROL

BOUNDARIES
WE SET

WHEN WE
SEEK SUPPORT

FILL IN THE GAPS WITH SOME OF YOUR OWN

WE CAN BRING BALANCE TO THE HARD
TIMES WITH A SLIVER OF SUNSHINE.

APPRECIATING THE GOOD, HOWEVER SMALL.

IT TAKES BOTH

SUNSHINE AND RAIN

TO MAKE A

RAINBOW

# USE THIS SPACE TO ACKNOWLEDGE YOUR STORMS and THEN FIND SOMETHING POSITIVE to REFOCUS YOUR THOUGHTS

## something stormy

example:
I am struggling with the juggle of work and kids.

## a positive thought

example:
I need to ask for help - my friends will be happy to lend a hand.

something stormy

a positive thought

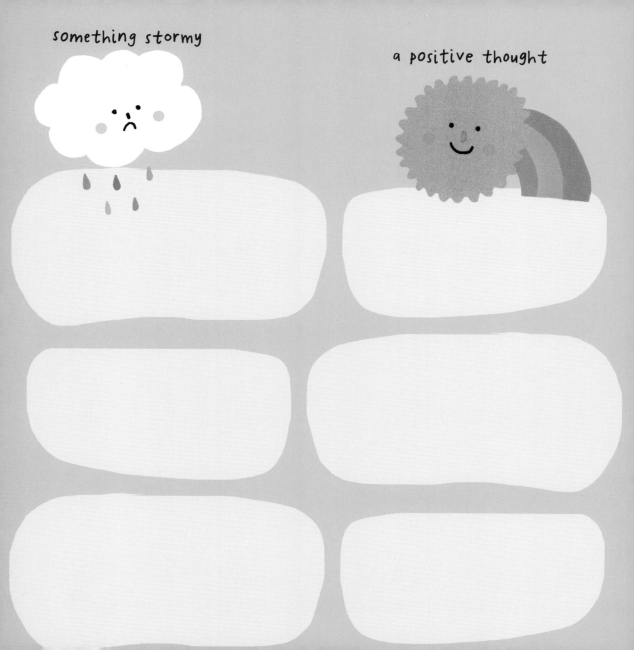

Chapter 4

# IT'S OKAY

We can give ourselves permission to find some things
hard, even when other people don't understand.

It's totally fine to live by our own rules.

The world won't end if we make mistakes or choose
to start again.

We are allowed to change, grow and become different
versions of ourselves,
to accept ourselves as we are,
and forgive our previous errors.

It's totally, 100% okay.
You are not failing.

# IT'S OKAY

* TO MAKE MISTAKES
* TO HAVE BAD DAYS
* TO BE LESS THAN PERFECT
* TO DO WHAT'S BEST FOR YOU
* TO BE YOURSELF

When you need some extra reassurance, here's list of It's Okays.

Even when we know these things to be true, it helps to see it written down.

DEAR _____

# IT'S OKAY

* _____

* _____

* _____

* _____

* _____

Create your own memo.
A visual reminder that you're only human.
Cut yourself some slack next time things are
a little tough.

# YOUR STORY

# MATTERS

Accept all the versions of you: past, present...
and the extra-awesome you still to come.

ACCEPTANCE

It's okay if our growth is messy
and imperfect.

We are all works in progress, doing
our best.

There are no prizes for struggling
through, though.

We can take time to pause and
catch our breath.
We don't have to manage alone.

It's okay to ask for help.

# WE WON'T ALWAYS GET IT RIGHT.

When things are hard, show yourself the same compassion and forgiveness you would show a friend.

# THINGS I FORGIVE MYSELF FOR...

It's okay to let go.
Fill the clouds with things you
forgive yourself for.

# REMEMBER

It's okay to show ourselves love and empathy. We deserve our own kindness.

It's okay to prioritize our own needs without justification or excuses.
We are not selfish for practising self-care - our energy, time and feelings are worth protecting.

It's okay to set boundaries and to do all we can to help us keep sparkling.
We have to show people how we expect and deserve to be treated.

DON'T BELIEVE EVERYTHING
YOU THINK.

WE ARE MADE OF MORE
THAN OUR DIFFICULTIES.

THERE IS LOTS
TO LOVE, TOO.

It's not always easy to practise self-love.

Our inner critics can be sneaky and persistent.

We find it so much easier to believe the negative than the positive - but in order to love ourselves a little more, we need to learn to be gentler with ourselves.

To focus on the positive.

To train our inner voices to be more compassionate and altogether a little kinder.

# SELF - KINDNESS

# SPEAK KINDLY TO YOURSELF

Practice positive self-talk by doodling yourself, and then fill the bubbles with positivity.

Next time you find you are doubting yourself or needing a pep-talk, look back at these pages.

I can ...

I'm great at ...

I felt proud when ...

... makes me awesome

YOU'RE REALLY RATHER WONDERFUL, YOU KNOW.

# THOUGHT SWAPS

I CAN'T  I WILL

I'M NOT ENOUGH  I'M DOING MY BEST

I CAN'T COPE  HOW CAN I MANAGE THIS?

I'VE MADE A MISTAKE  I'M LEARNING

I HAVE TO  I AM ABLE TO

I SHOULD  I COULD (IF I TRULY WANT TO)

I'M FLAWED  I'M PERFECTLY IMPERFECT

# AFFIRMATIONS

(for an everyday reminder of awesomeness)

I add value to the world

I am enough

I am worthy of my own love

I deserve happiness

I am growing and learning

I believe in myself

I am resilient and brave

I matter

I make a difference

YOUR WEIGHT

YOUR JOB

LIKES AND SHARES

WHAT OTHER PEOPLE THINK OF YOU

# THINGS THAT DON'T DEFINE YOU

YOUR AGE

YOUR STRUGGLES

YOUR PAST

YOUR CLOTHES SIZE

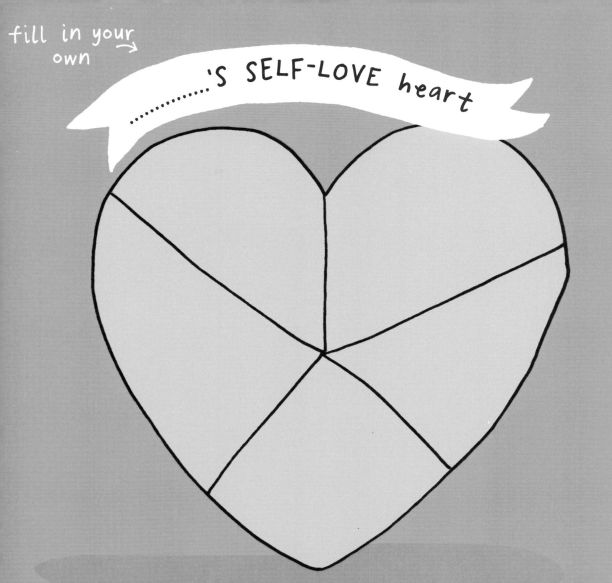

# PERMISSION SLIP

I GIVE PERMISSION FOR:  you
TO:  be your very truest, loveable self

COMMENTS: (you are not your thoughts)

SIGNED: Stacie          DATE: every day

DON'T
underestimate
undervalue
or
underplay
YOUR SPARKLE

you are truly magical

# HOW YOU LOVE YOURSELF IS HOW YOU TEACH OTHERS TO LOVE YOU

# YOU CAN BE A GOOD PERSON WITH A KIND HEART and STILL SAY 'NO'

Saying

# NO

shows that we value our:

- TIME
- NEEDS
- FEELINGS
- ENERGY
- IDENTITY

# BOUNDARIES

WAYS TO SAY NO

I CAN'T, BUT THANK YOU FOR THE OFFER

NOPE

SORRY I CAN'T HELP ON THIS OCCASION

I'M AFRAID I CAN'T

THAT WON'T WORK FOR ME

MY DIARY IS FULL

NO WAY

NO, THANK YOU

I'LL HAVE TO PASS

MAYBE ANOTHER TIME

IT IS NOT YOUR JOB
TO BE
EVERYTHING
TO EVERYONE
—
♡

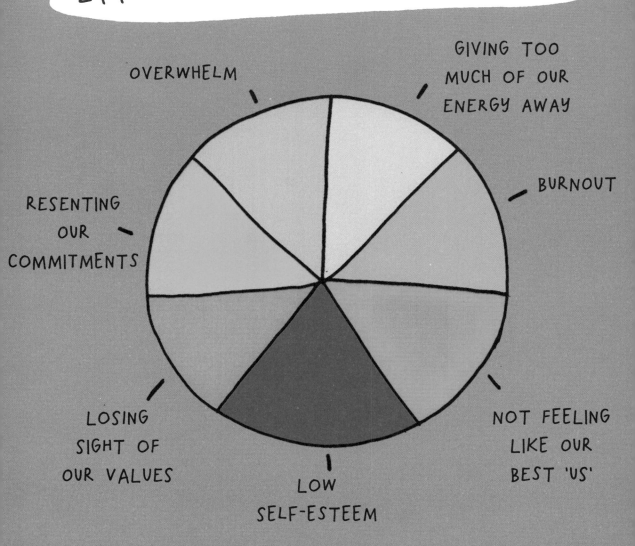

NOT
ALL
PROBLEMS
ARE OURS
TO
SOLVE

# I WILL SAY NO TO

Make a note of your NOs.

Assert your boundaries.
Set your limits.
Be firm.

(Even if other people don't like it.)

# BOUNDARIES CHECKLIST

⭐ Identify your boundaries
- what do you want / need / feel...?

Acknowledge your limits and practise
saying them out loud

⭐ Express your boundaries clearly
and assertively

Consider the consequences for anyone who
disregards your boundaries

⭐ Let go of guilt;
trust your instincts

# WHAT DO YOUR BOUNDARIES LOOK LIKE?

Fill in the rainbow arc with the values and limits you would like to assert.

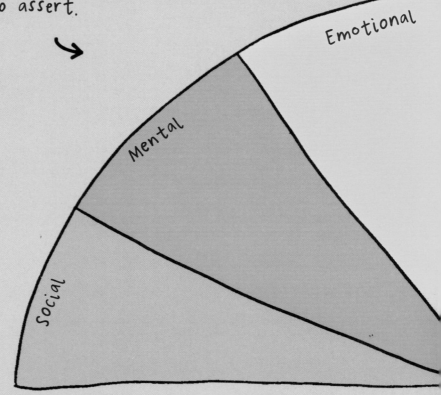

example: work ...
'I won't check or respond to work emails
after 6pm.'

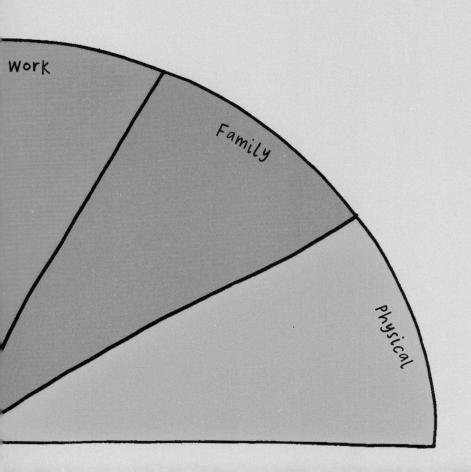

IT'S OKAY TO DO WHAT'S BEST FOR YOU.

# NO

IS A COMPLETE SENTENCE

# BUT SAY YES TO SELF-CARE

# SAY YES

To offers of help
To things that make you smile
To taking time for yourself
To positive thoughts
To being you

Forget bath bombs and candles,
Put down the face mask,
While they can be self-care,
There's more to the task.

Make sure you drink water,
Take all of your meds,
Get outside for a stroll,
Be early to bed.

Read a good book, switch off your screens,
Journal your thoughts, anxieties and dreams.

Ask for help when you need it,
Set boundaries in place,
Trust in your journey; life's not a race.

Take care of yourself, and be kinder to you,
Self-care is remembering, that you matter too.

# 5-MINUTE SELF-CARE

WRITE DOWN 3 NICE THINGS ABOUT YOURSELF

STEP OUTSIDE FOR SOME FRESH AIR

FIND A VIDEO OF SOME CUTE ANIMALS ONLINE

DRINK SOME WATER

LISTEN TO A SONG THAT MAKES YOU SMILE

BOOK THE APPOINTMENT YOU HAVE BEEN PUTTING OFF

DO A SHORT MINDFULNESS BREATHING EXERCISE

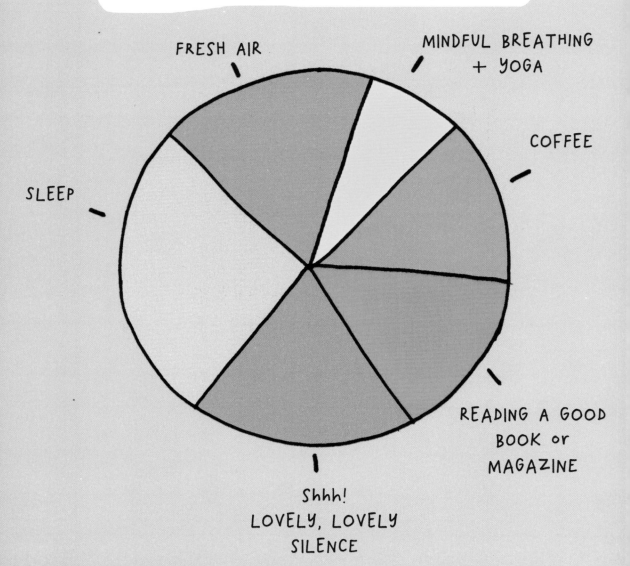

..........................'s Circle of Self-Care

fill in your own

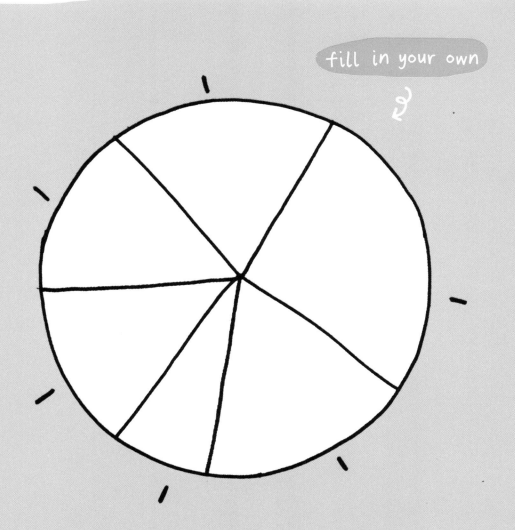

Self-care is
the fuel that
allows your
light to shine
brightly.

Unknown

MAKE YOURSELF a PRIORITY.

# THINGS I WILL SAY YES TO

What acts of self-care can you say YES to...
An earlier bedtime?
Arranging your medical appointments?
A gratitude journal?

Fill in the banners with your self-care intentions.

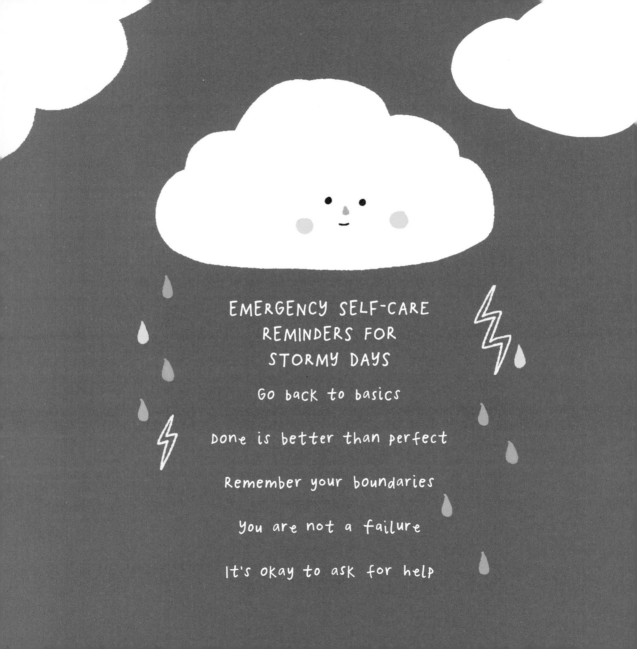

EMERGENCY SELF-CARE
REMINDERS FOR
STORMY DAYS

Go back to basics

Done is better than perfect

Remember your boundaries

You are not a failure

It's okay to ask for help

# Believe You Can

YOU DESERVE GOOD THINGS.
YOU DESERVE TO BE HAPPY.
YOU ARE CAPABLE
AND COMPETENT.

DON'T DOUBT YOUR SPARKLE.

*WORTHY*

IT'S NOT DOWN TO LUCK

IT'S DOWN TO YOU

# Gold stars

Fill the stars with your proudest moments and achievements - all the things that make you feel twinkly and good about yourself.

# IT'S OKAY TO BE a WORK IN PROGRESS.

Our self-belief and sense of worth can be easily rocked in times of stress or uncertainty.

Take time to remember the accomplishments, self-care measures and abilities that make you more than capable.

I HAVE ...

...................................................................

...................................................................

...................................................................

...................................................................

...................................................................

...................................................................

If you need some examples:
I HAVE practised ways to say 'NO' → SO I CAN confidently decline that invitation.
I HAVE survived all of my bad days → SO I CAN get through this tricky situation.
I HAVE experience and training → SO I CAN totally lead the presentation at work.

SO I CAN ...

..........................................................

..........................................................

..........................................................

..........................................................

..........................................................

..........................................................

You have survived
every storm.

I'M CHEERING YOU ON!

# IT'S COOL TO BE KIND

We have the ability to brighten someone's day, to be the rainbow in their rainclouds with a kind word or a thoughtful act.

And in turn, being kind makes us feel better and sparklier too.

Even the smallest acts of kindness hold great power.

# WAYS TO HELP SOMEONE GOING THROUGH A CLOUDBURST

Be empathetic

Don't try and 'fix'

Ask what they need

Listen

Give them your time

Be non-judgemental

**I PROMISE TO:**

Give you the practical help
you need

Not trivialize your anxieties

Listen without judgement

Bring you chocolate

Fill in your own promise for someone having a hard time.

NO ACT OF
KINDNESS,
no matter how small,
IS EVER WASTED.

Aesop

KIND
NESS
IS
FREE

# FREE COMPLIMENTS

take one or pass it on

Copy this page and pop it up to spread some kindness.

- you make me smile
- you are awesome
- you are super brave
- you make the world a sparklier place
- I'm so proud of you
- you brighten up my rainy days
- I appreciate you
- you are an inspiration

WAYS TO BE KIND ONLINE

♡ Like and share posts

♡ Send a message of gratitude or support

♡ Interact and make connections

♡ Use your platform to share your favourite small businesses

♡ Credit content makers

# OTHER WAYS TO BE KIND ...

- Hold the door open for the person behind you
- Buy someone a cup of coffee
- Donate to your favourite charity
- Pick up litter
- Leave a positive review

Send some snail mail

Lend someone a good book

Tell someone you love them

Donate food to a food bank

Smile at strangers

Let someone in front of you in a queue

Support a local charity

Check in on a friend

Be the cheerleader.
Champion your friends; remember
their successes.
Don't forget the details.
Shout loudly about the things you love
most in other people.
Build a community.
Know there is space for all of us to
make it.
Shine a light.
Be kind.

# ACTS of KINDNESS LOG

a space to record your acts of kindness

# OTHER AWESOME THINGS

Here's to facing our most challenging days with positivity, to loving ourselves a little harder and acknowledging all of the awesome things that help to make us feel super sparkly and twinkletastic.

AWE

SOME

LOOK for the

# JOY

in every day.

Find the things that lift you up.
Seek out the people who make you smile.

# REASONS to SMILE

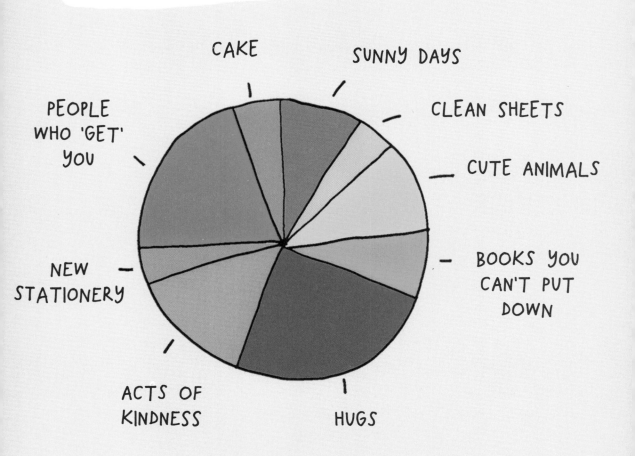

PRACTISE GRATITUDE

Even our dullest days can give us cause to
be thankful.
Our messy times can also be a chance to
learn and grow.
There is joy to be found in the mundane
and happiness hidden in each day.

## everyday things I am grateful for:

- [ ] ------------------------------------------
- [ ] ------------------------------------------
- [ ] ------------------------------------------
- [ ] ------------------------------------------
- [ ] ------------------------------------------
- [ ] ------------------------------------------
- [ ] ------------------------------------------

Create your own gratitude checklist.

MAKE TIME FOR A SLICE
OF CAKE and A GOOD BOOK

(hurrah for small pleasures)

# NOTES to SELF

fill these pages with all the reminders, quotes and memos that uplift you.

YOU'RE SO COOL

fill the sunbursts with nice things you are told - read back when you need some sunshine in your day.

# Compliments I've received ...

You are twinkletastic.

You are unique.

YOU ARE POSITIVELY AWESOME!

First published in the United Kingdom in 2020 by Pavilion
43 Great Ormond Street
London
WC1N 3HZ

ISBN 9781911641995

A CIP catalogue record for this book is available
from the British Library.

10 9 8 7 6 5 4 3 2 1

Reproduction by Rival Colour Ltd, UK
Printed and bound by Toppan Leefung Printing Ltd, China

www.pavilionbooks.com